Same designs from Vol. 1 plus featuring a handful of up and coming designs for future volumes soon to come.

Hope you enjoy!

Be sure to like us on Facebook
www.facebook.com/coloringwithsteve

Tell your friends and family where to get their own copy below:

coloringwithsteve.com

I0404261

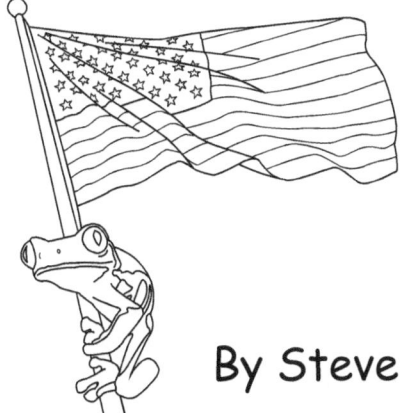

By Steve Jennings

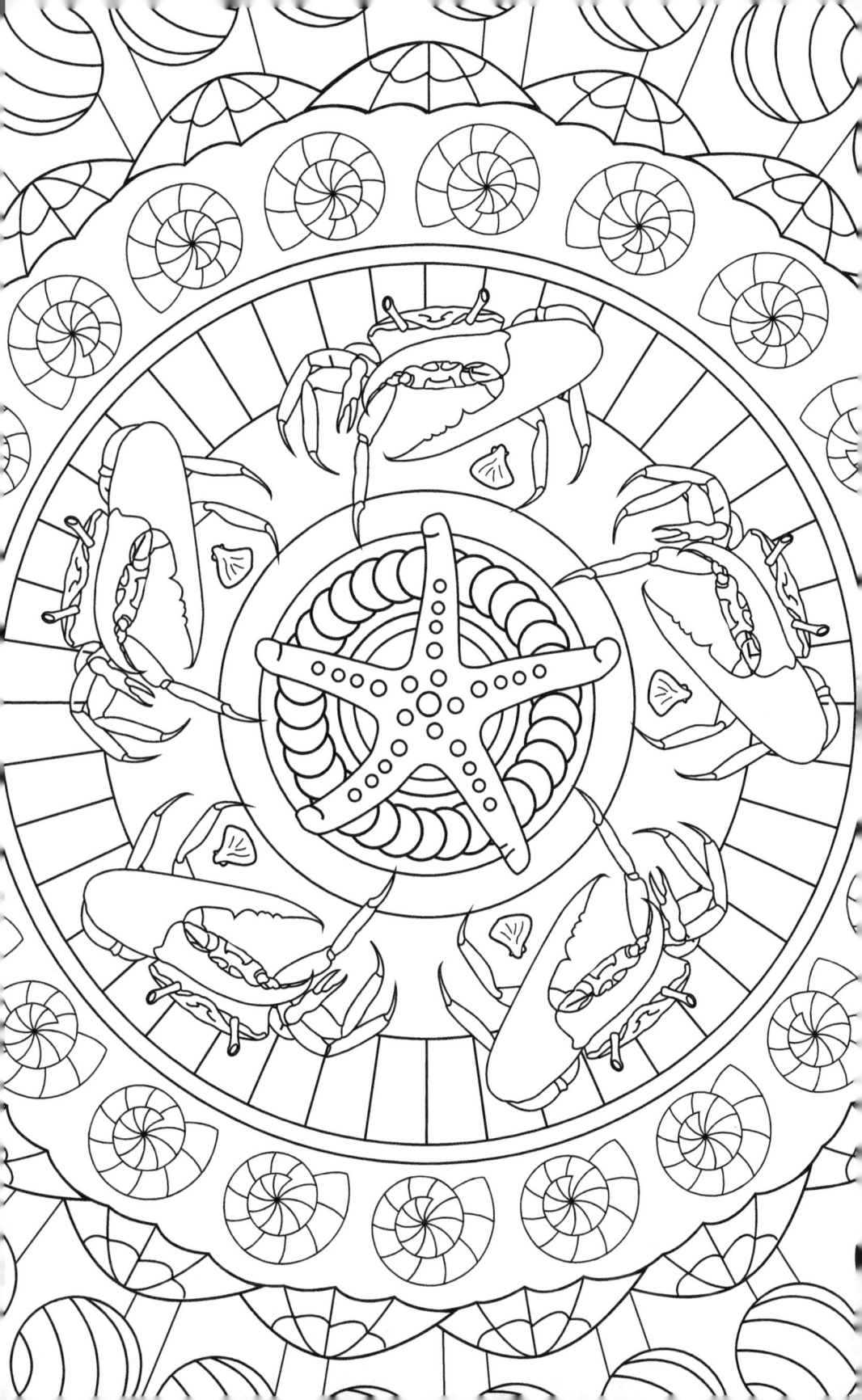

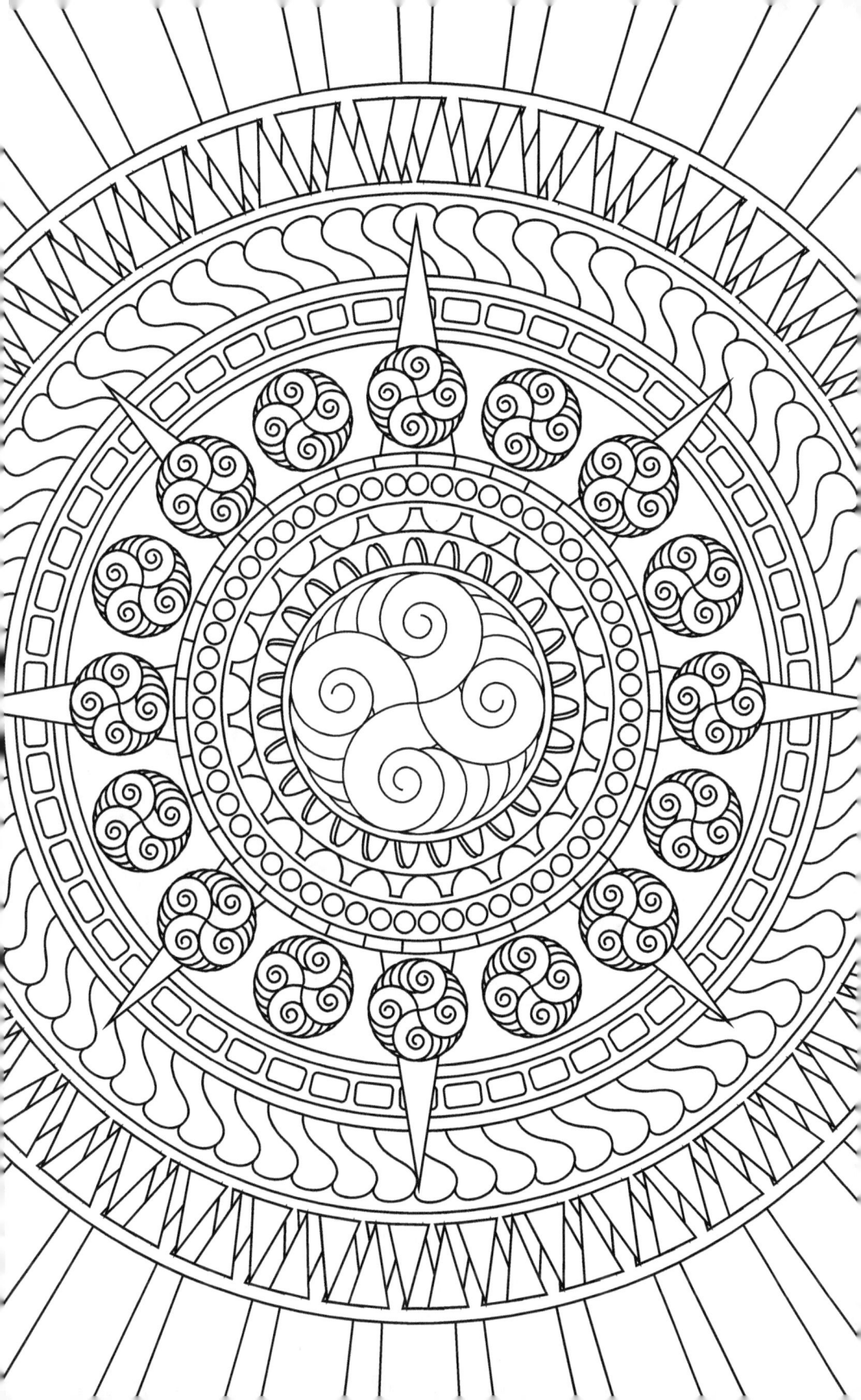

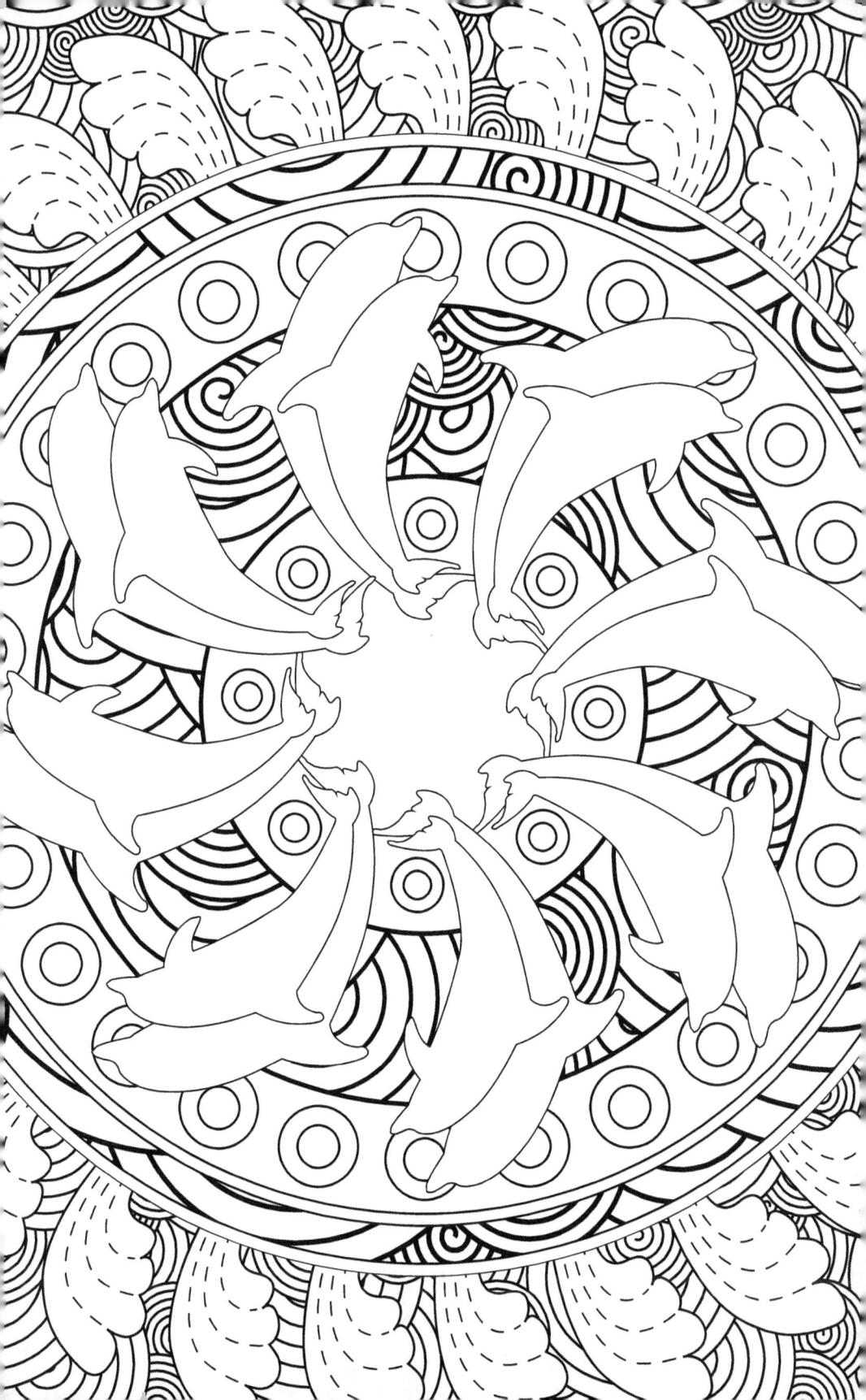

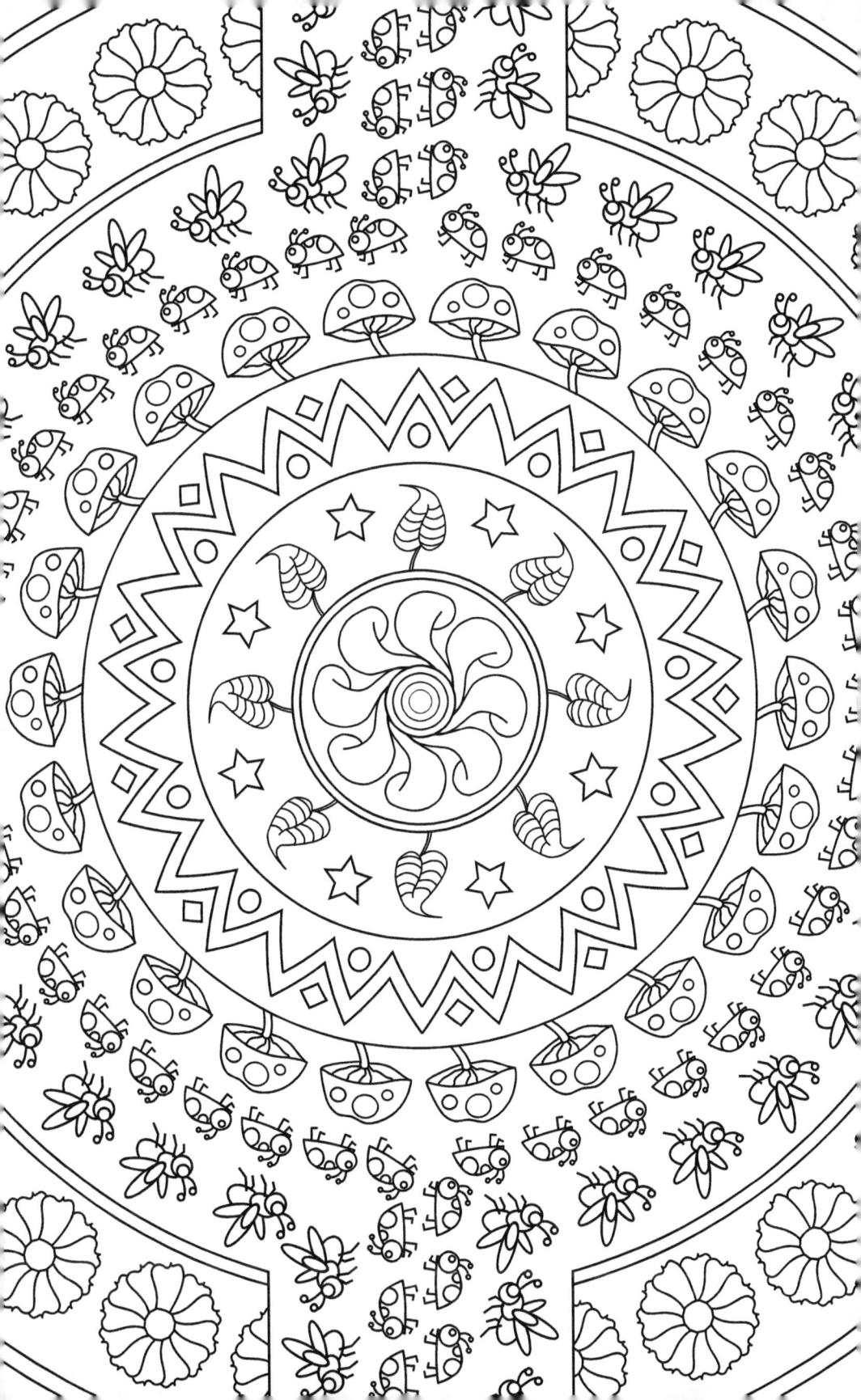

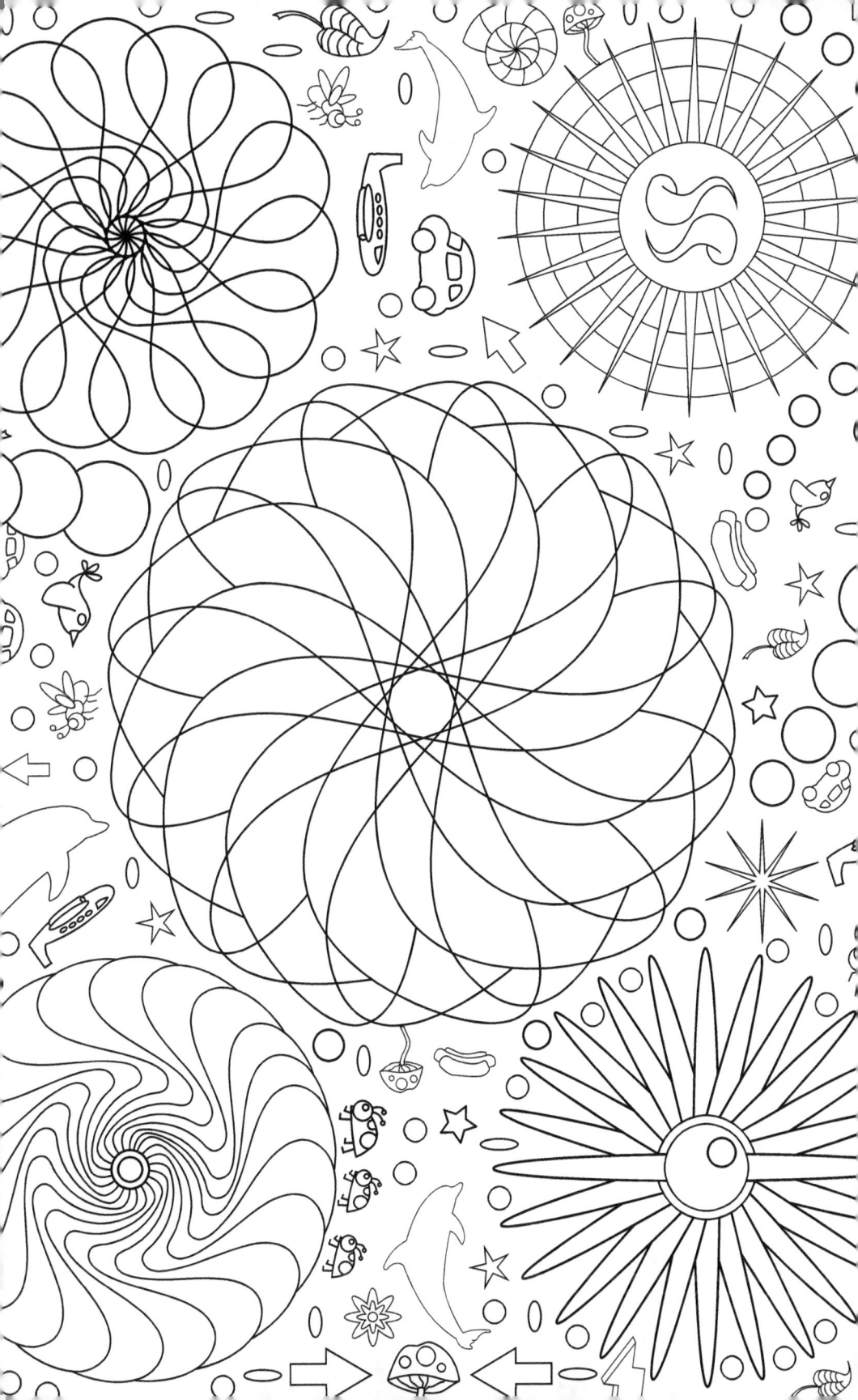

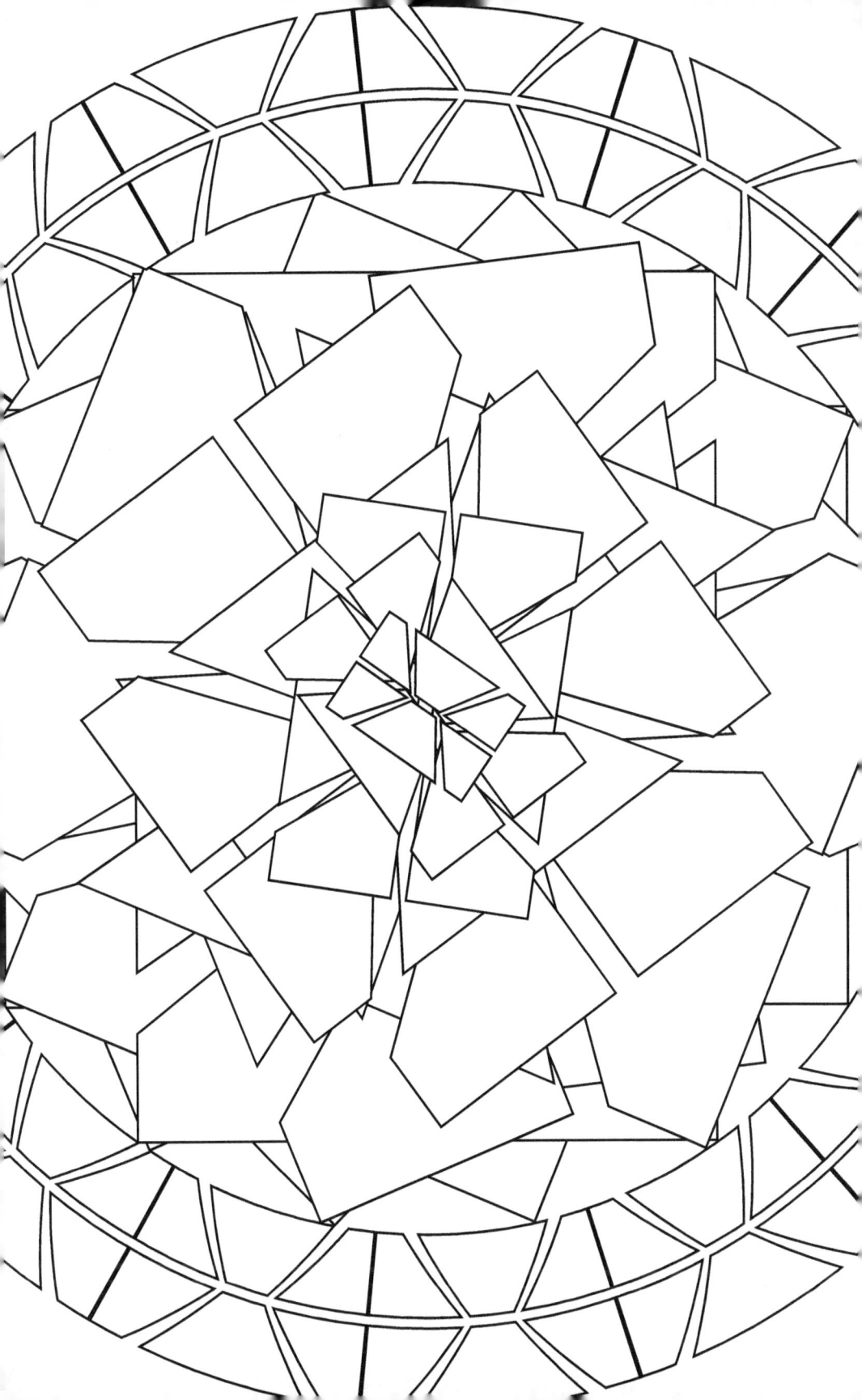

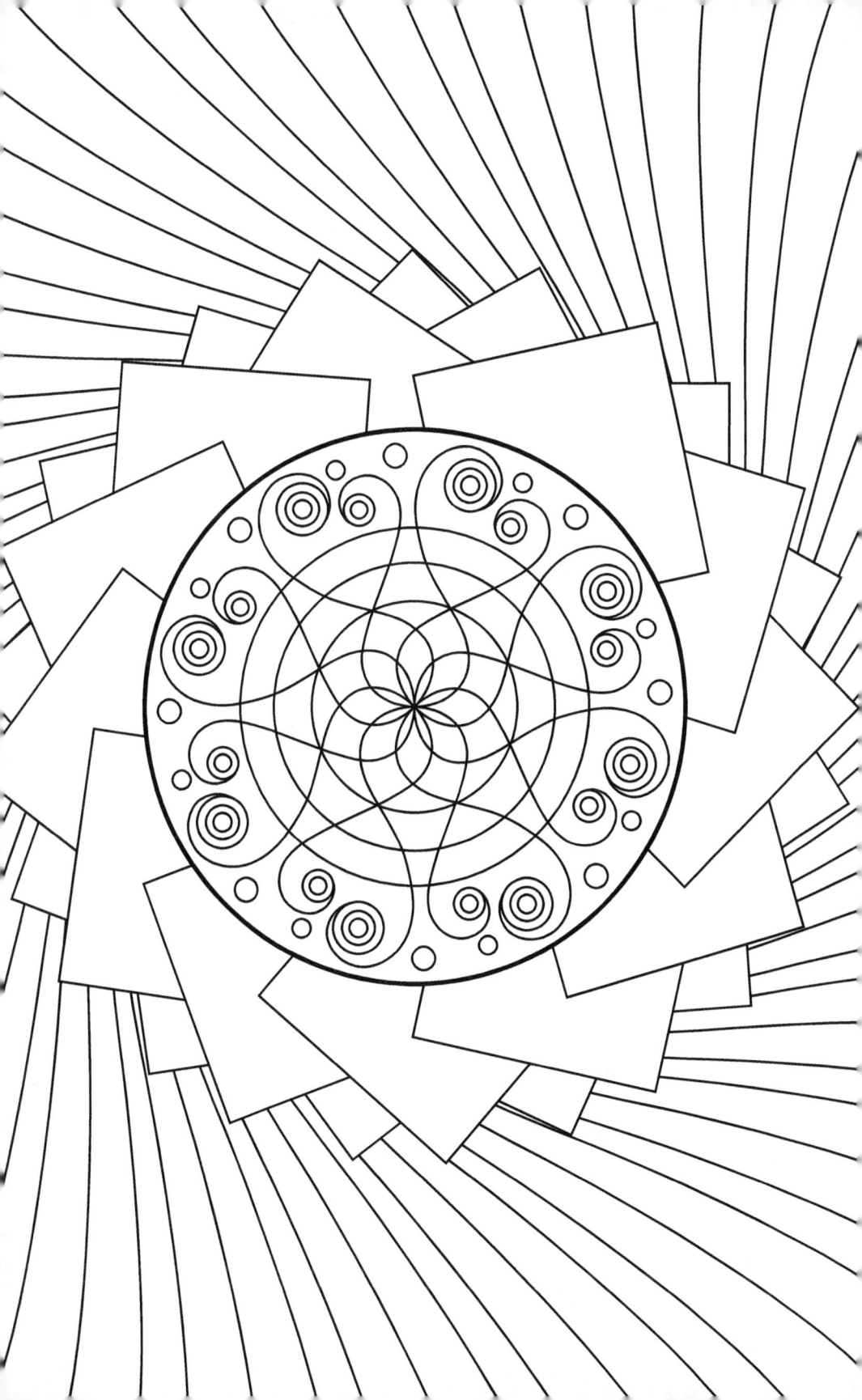

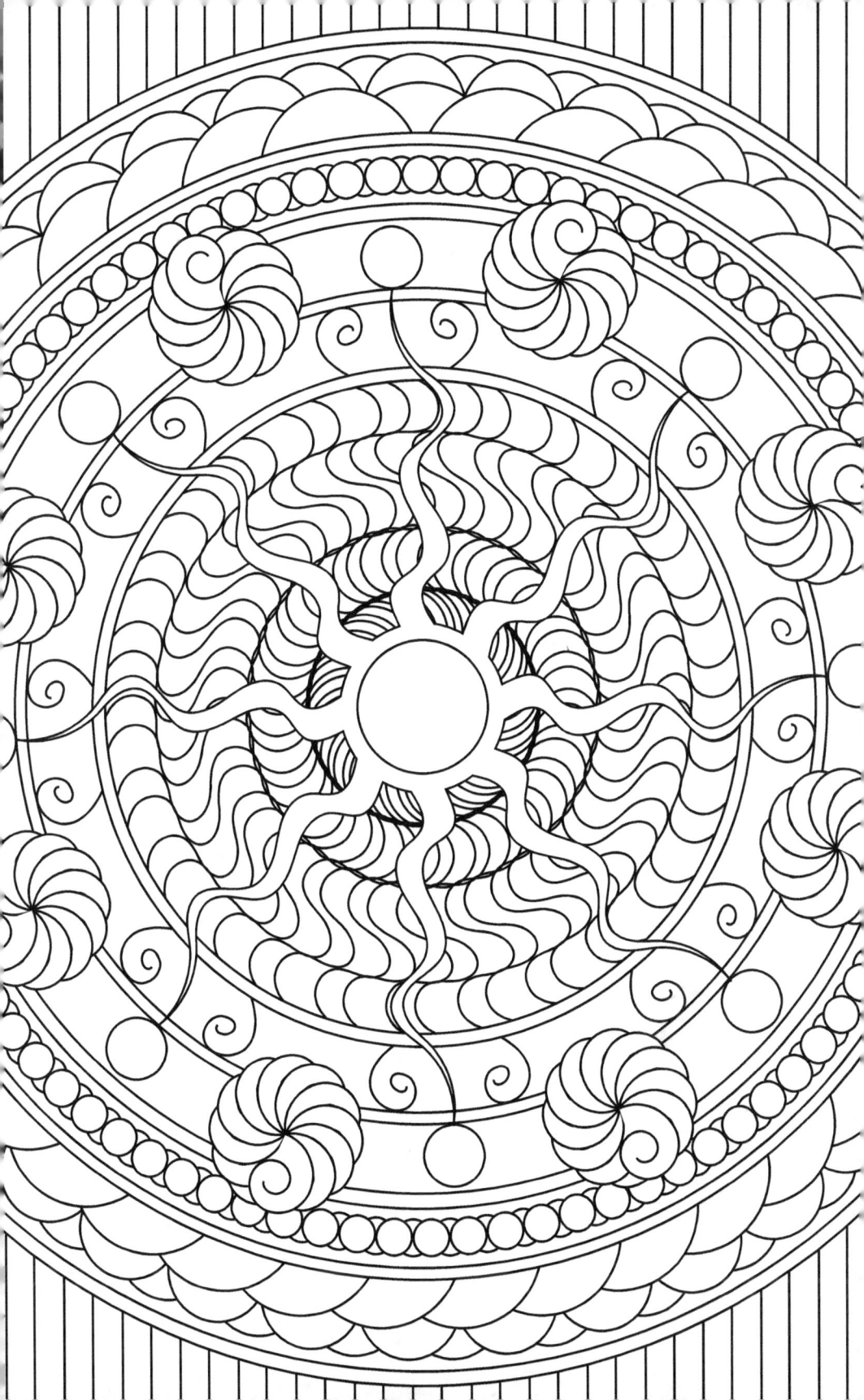

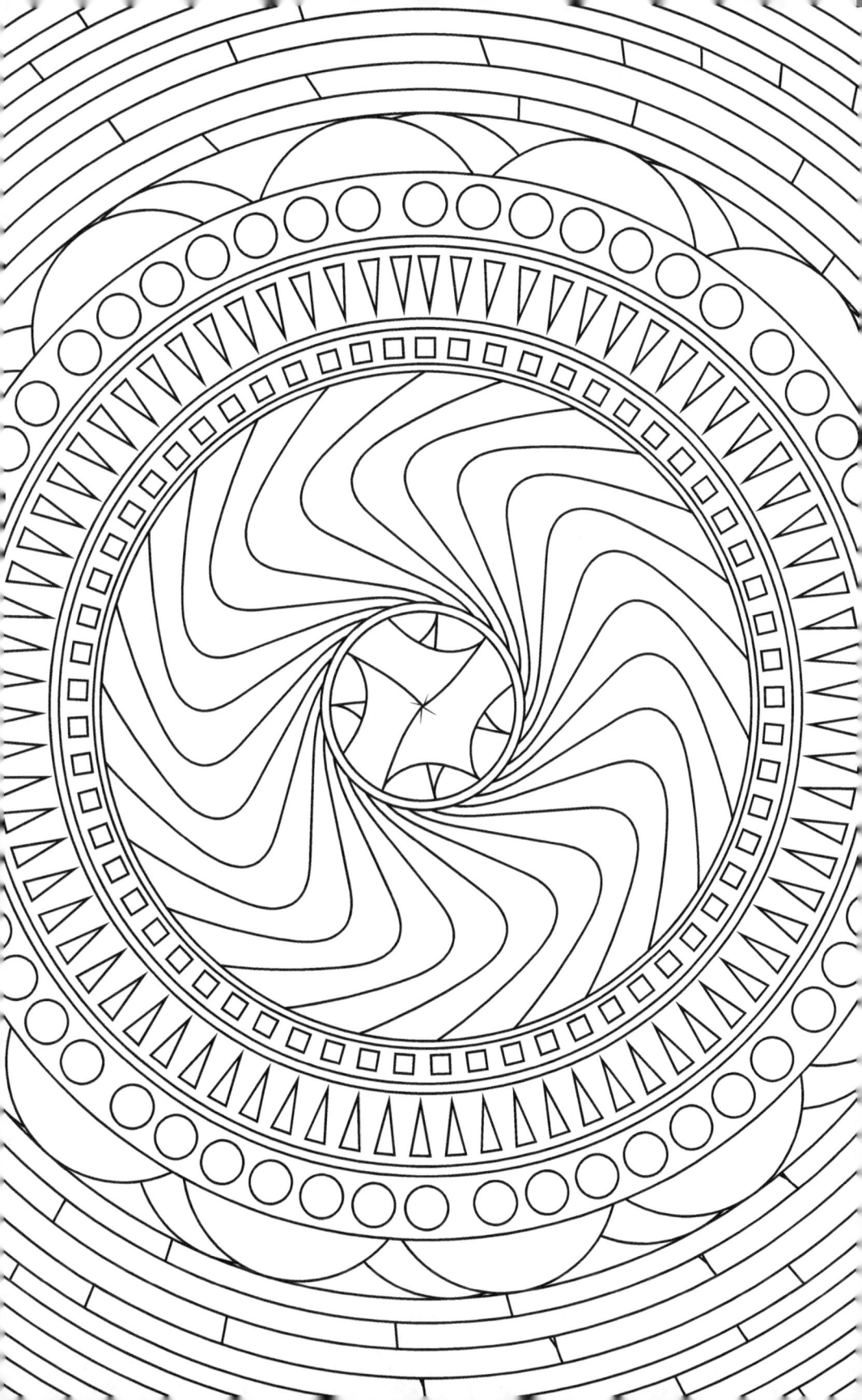

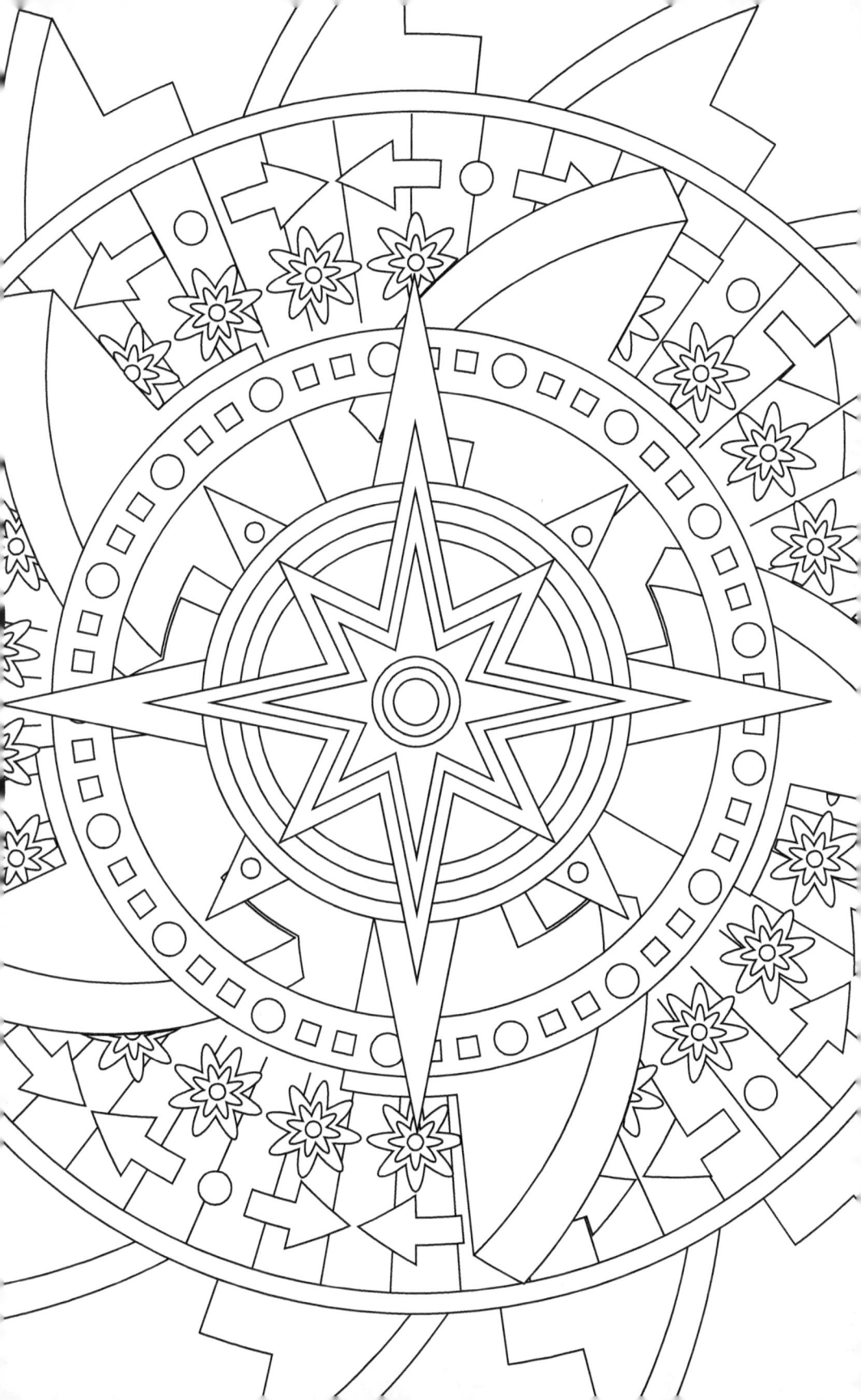

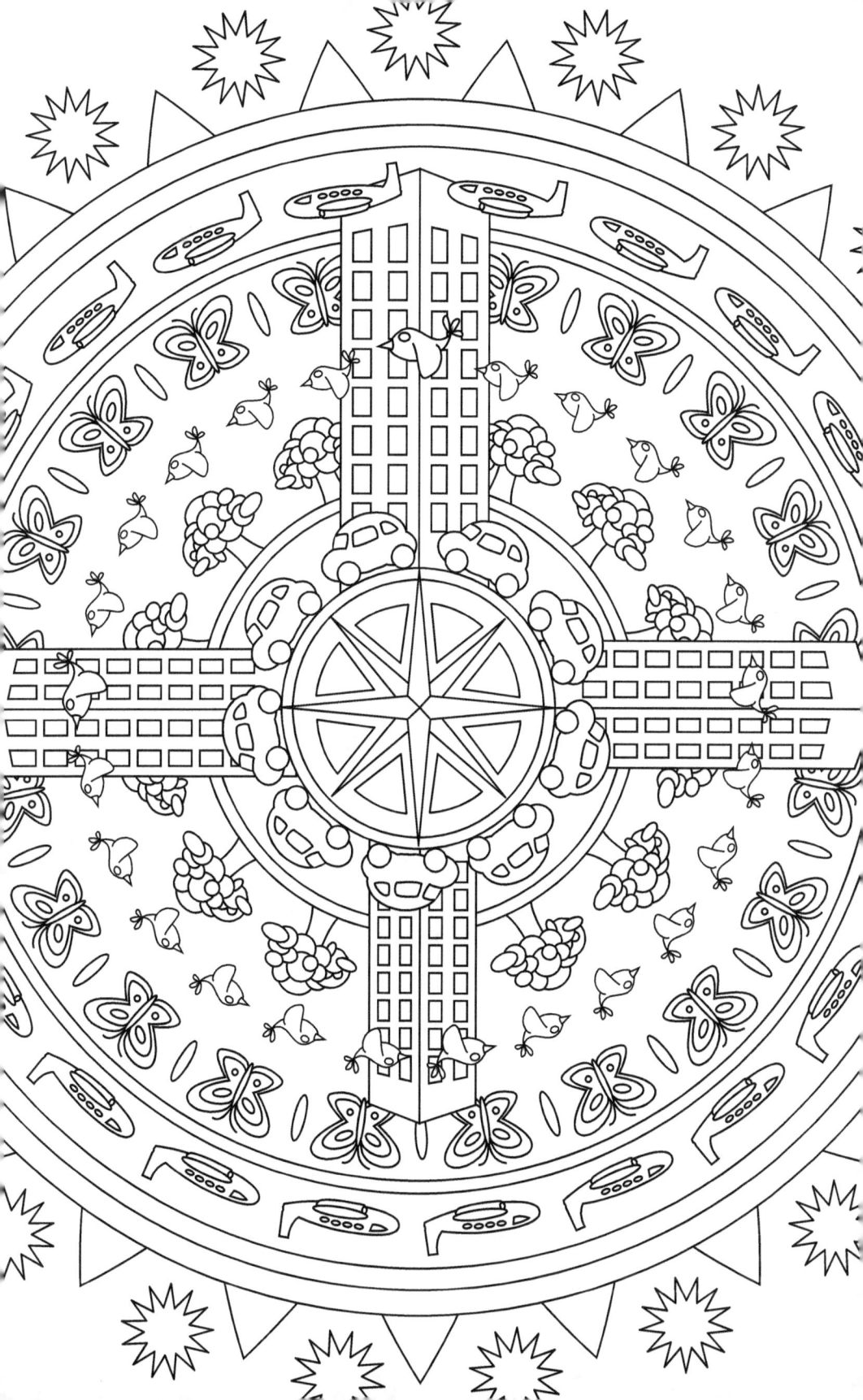

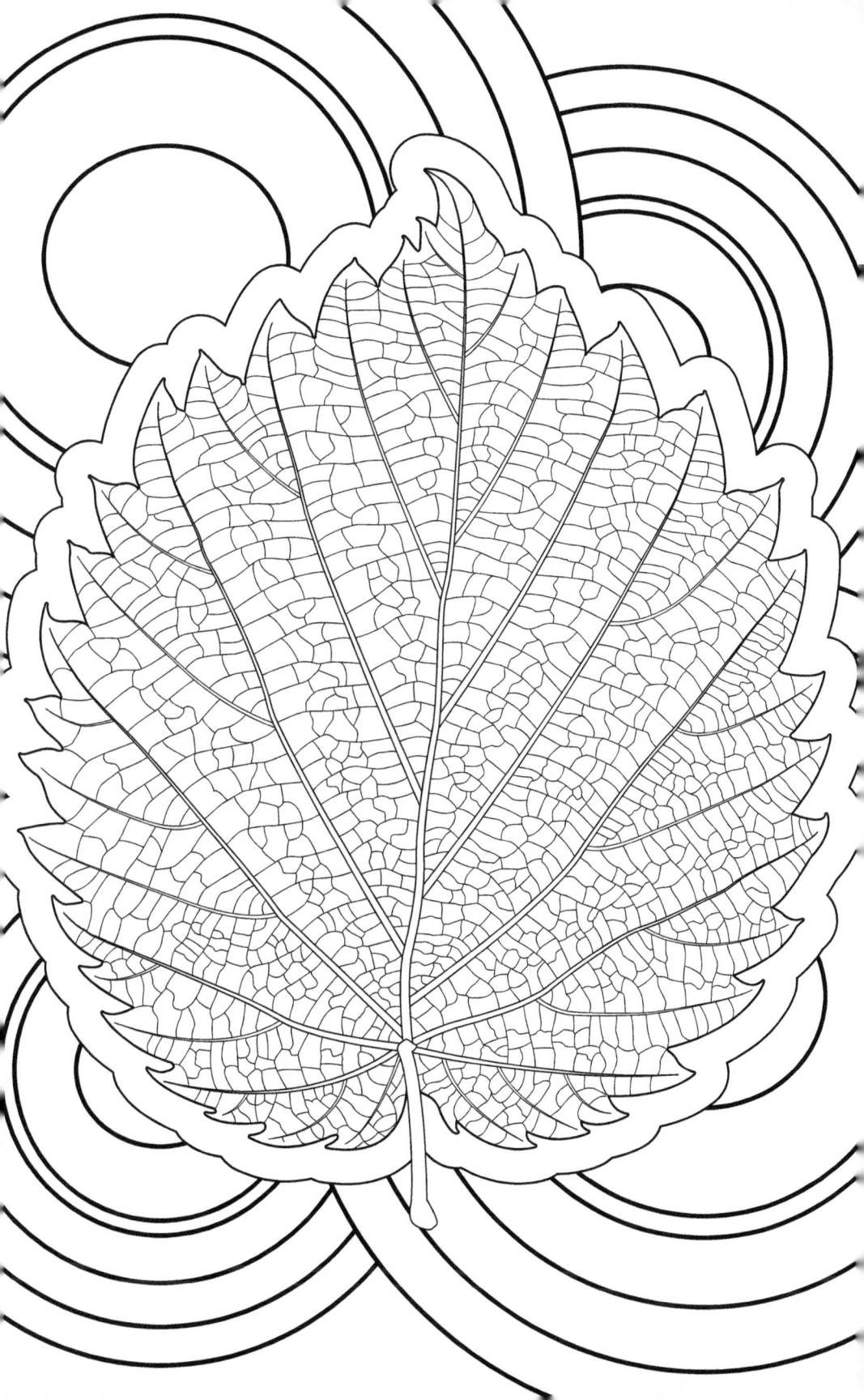

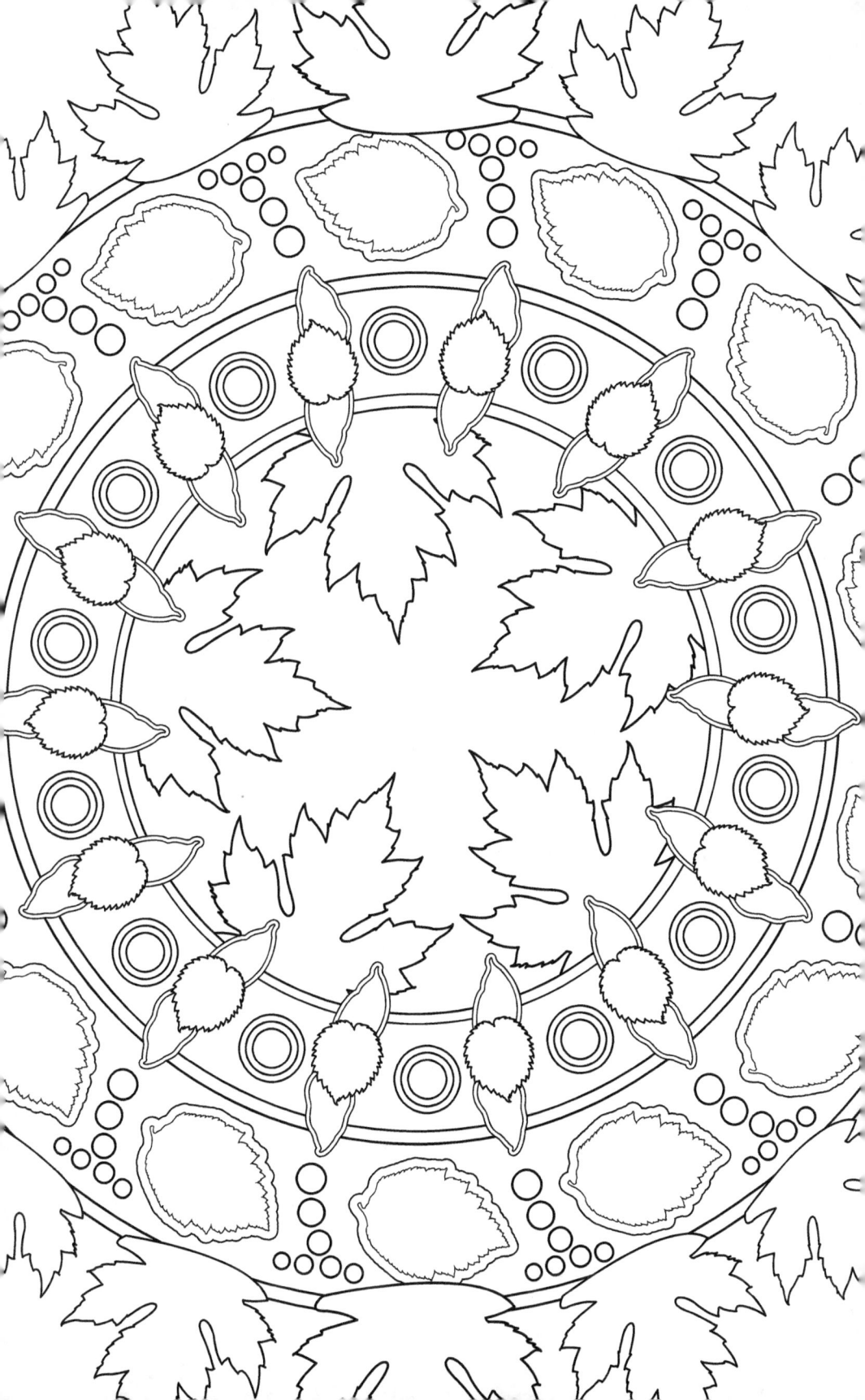

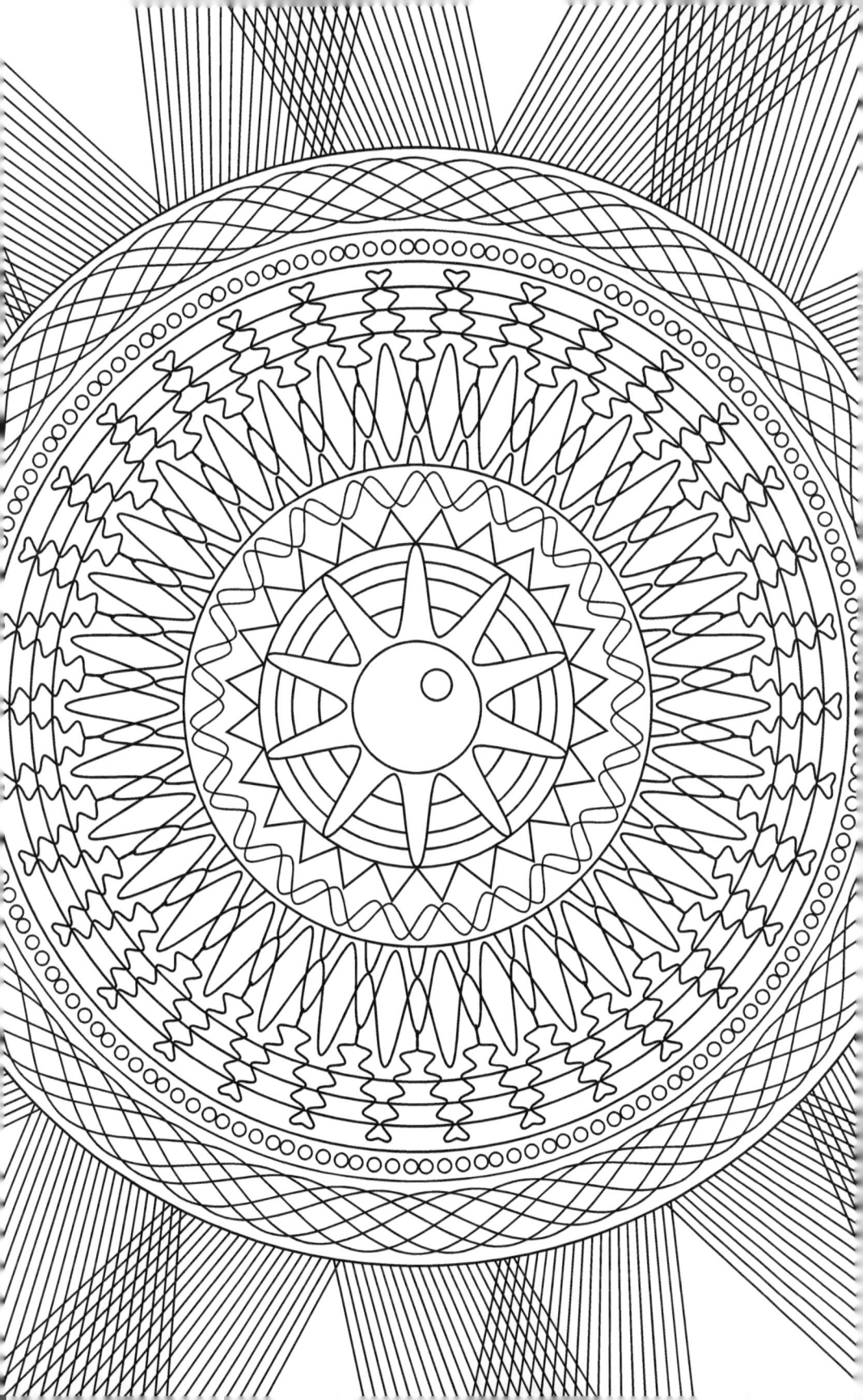

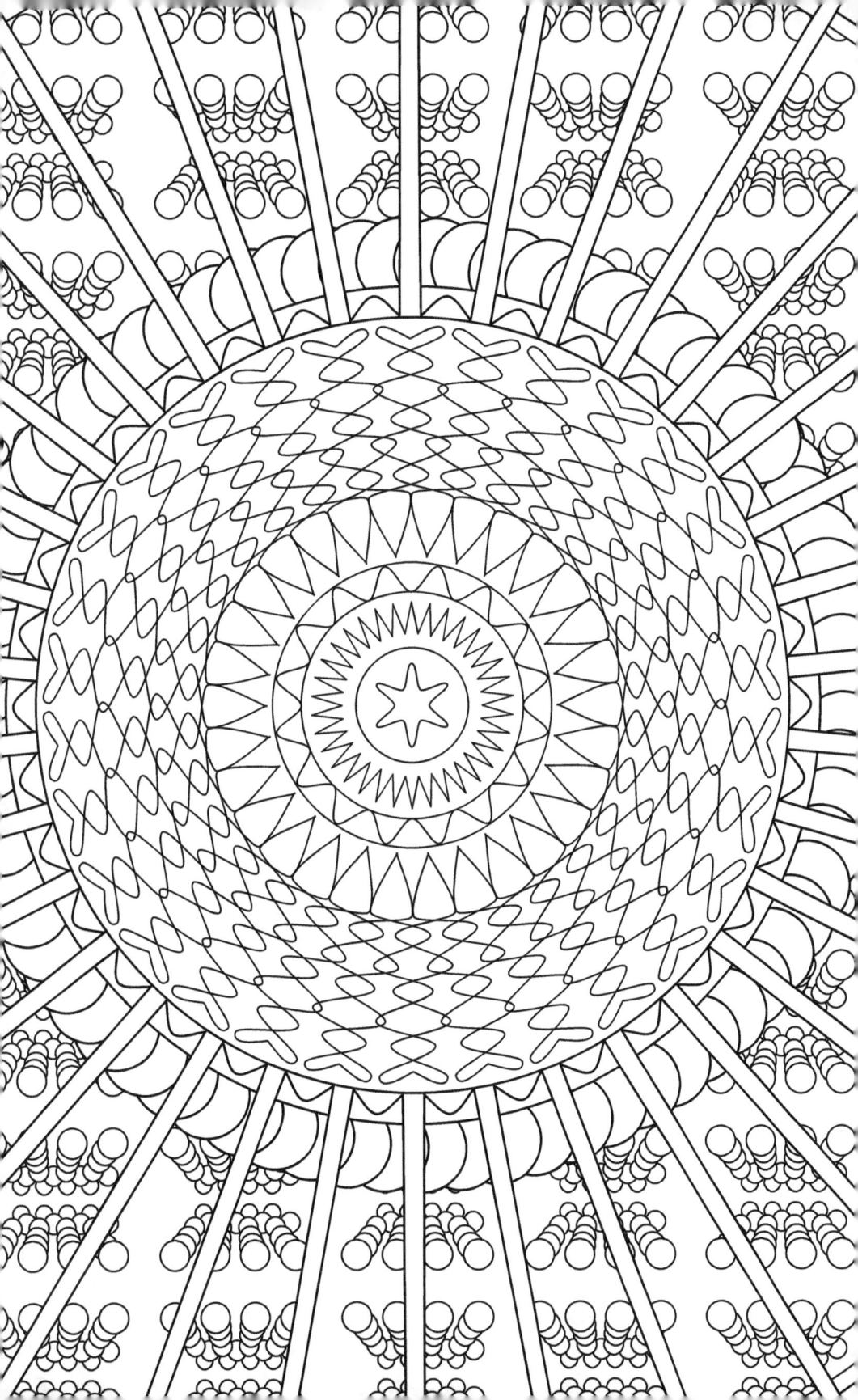

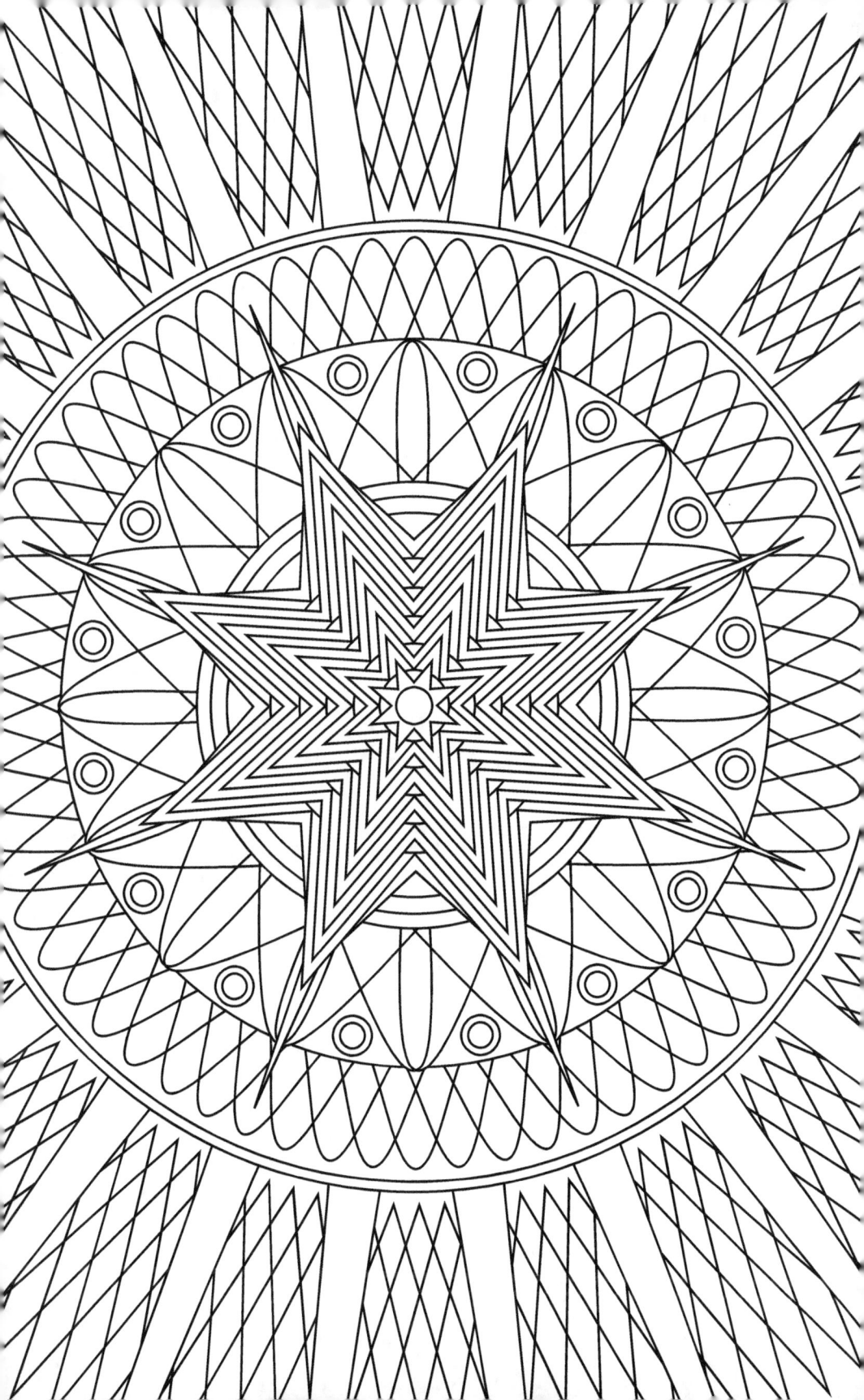

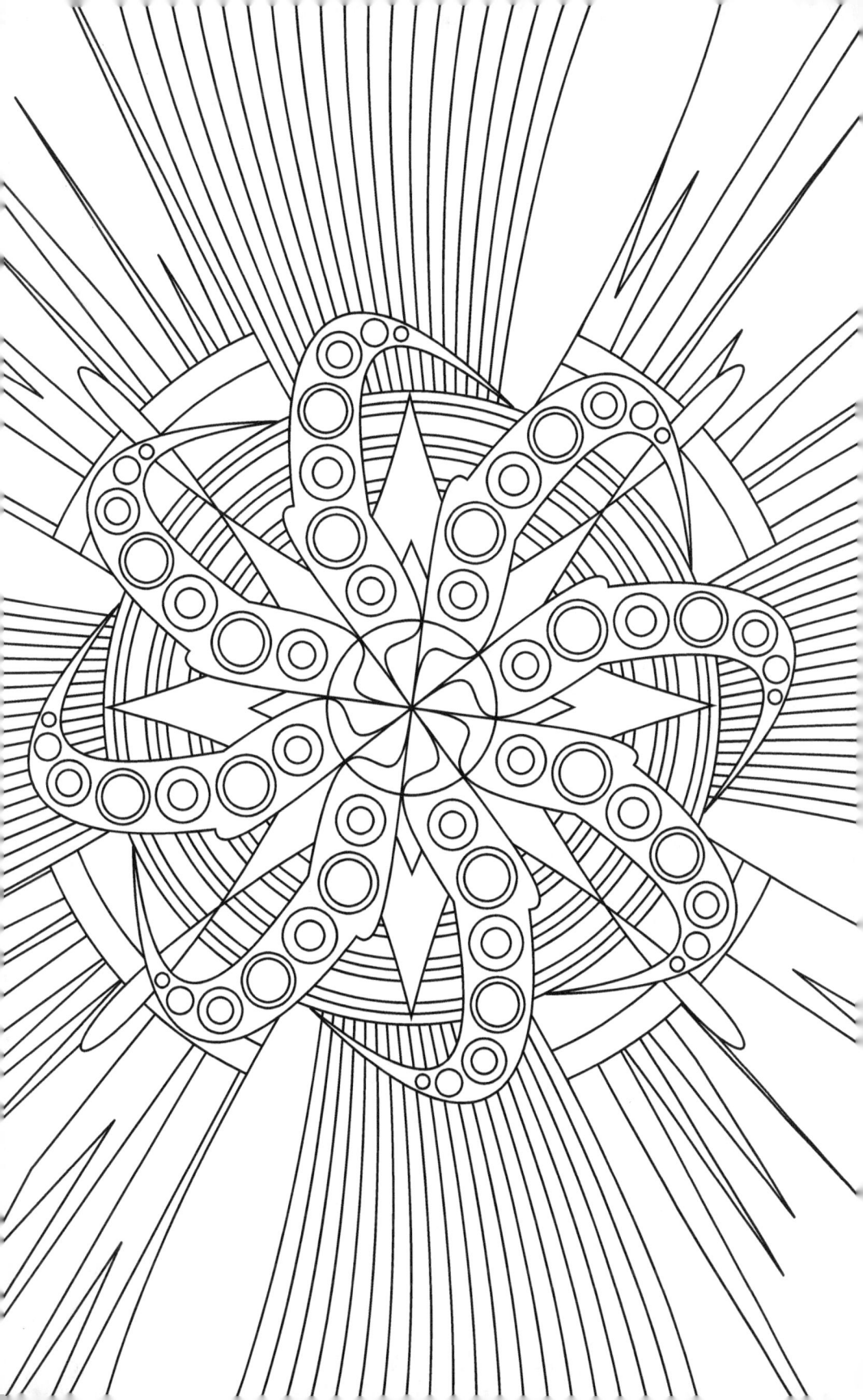

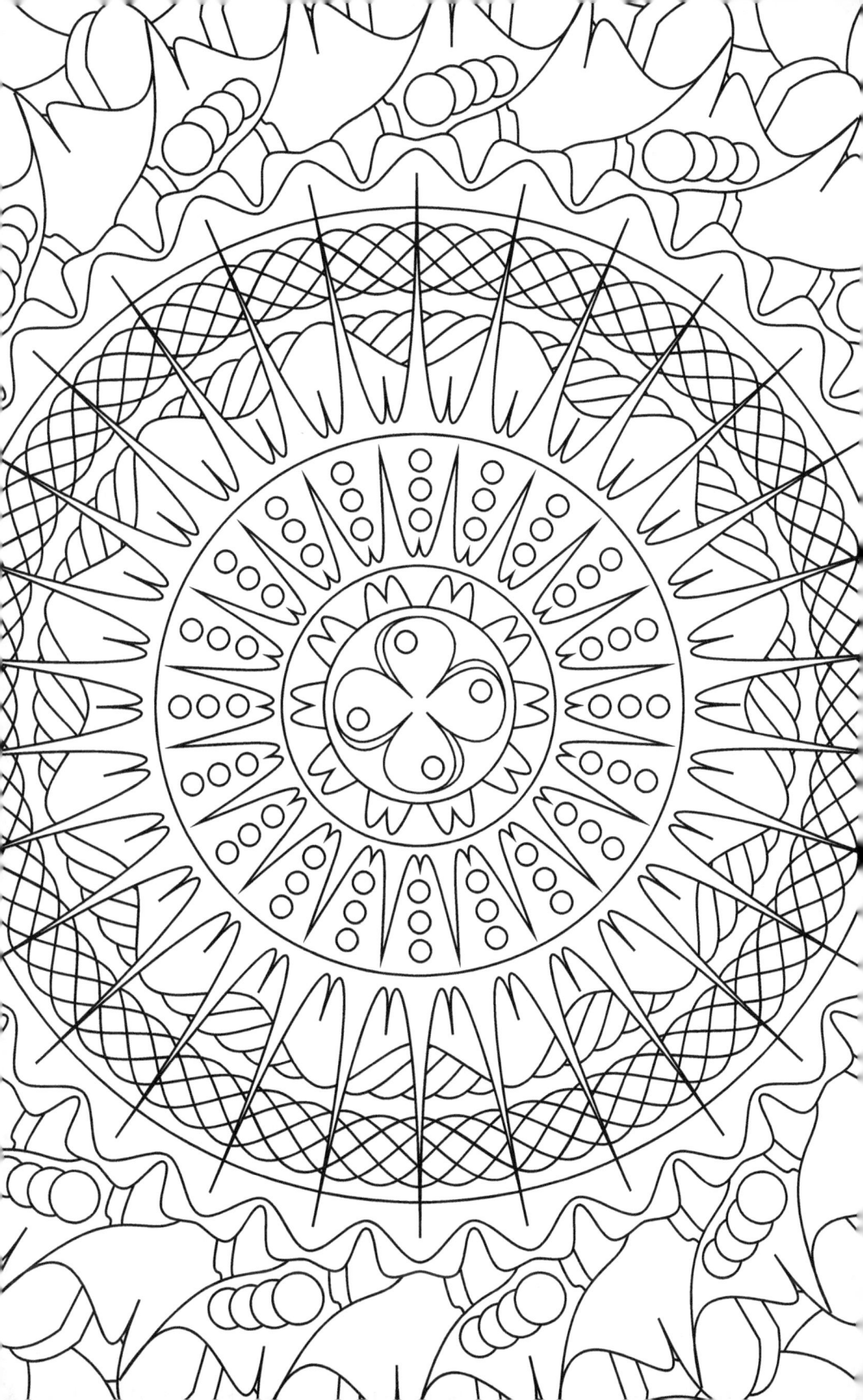

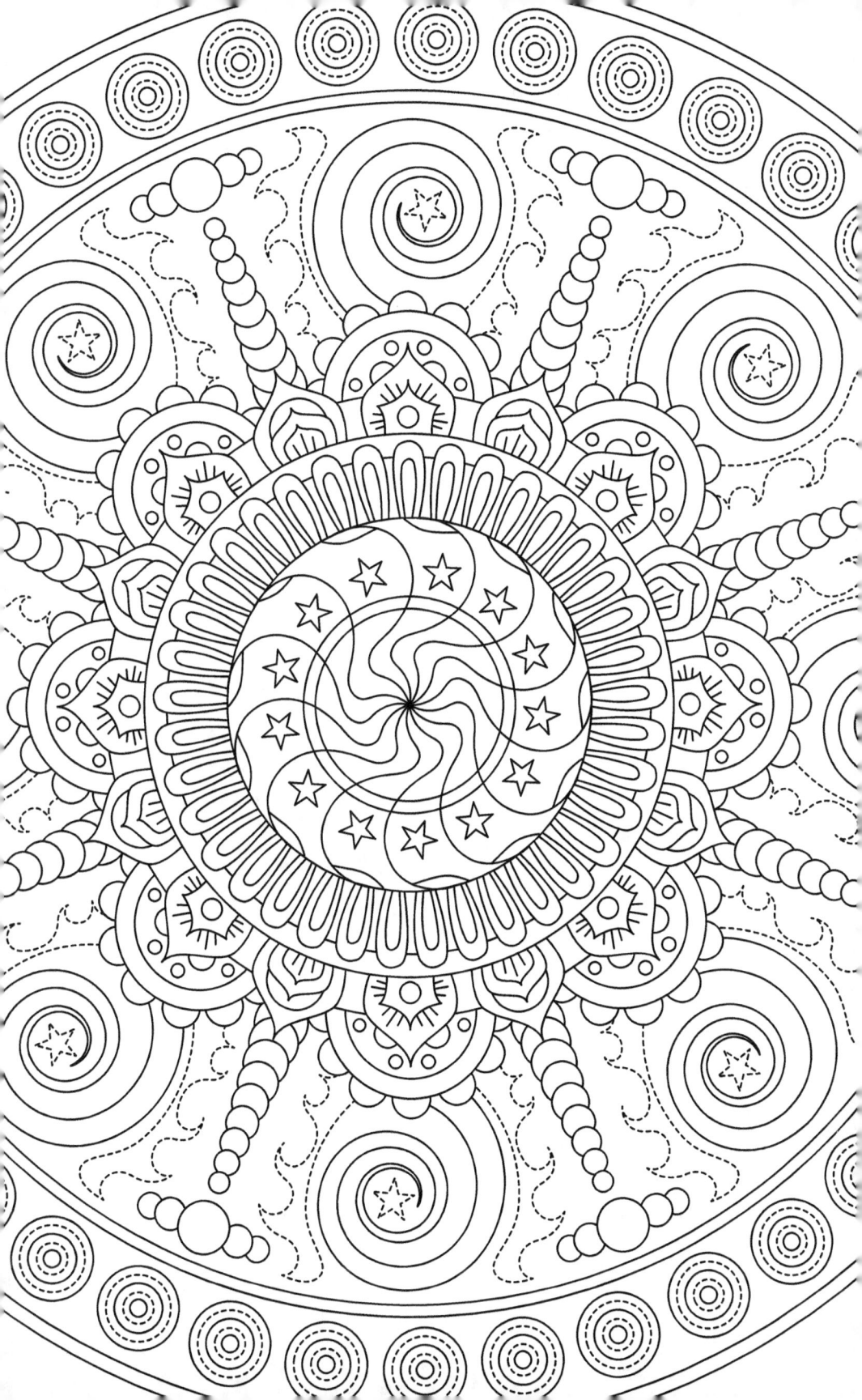

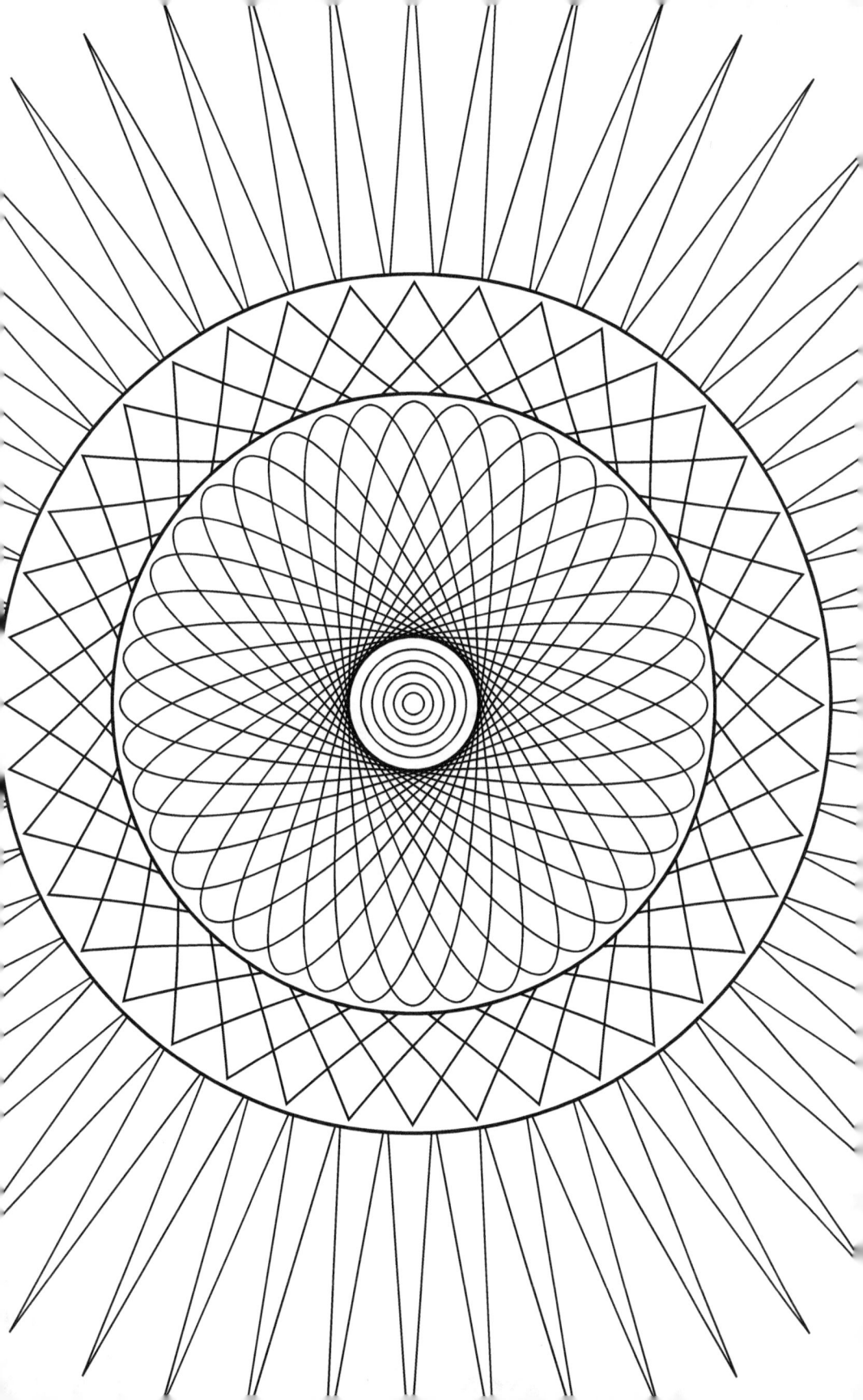

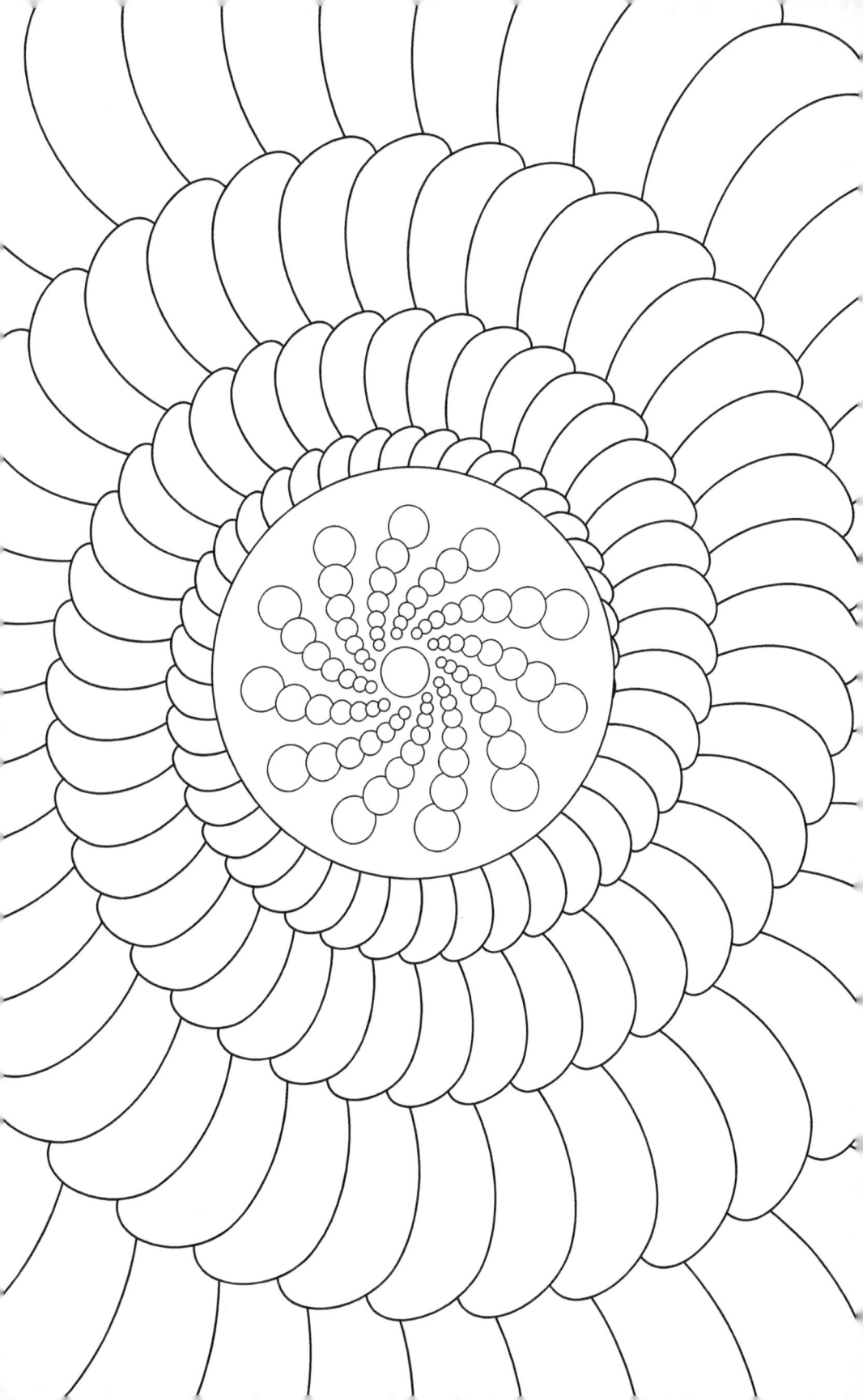

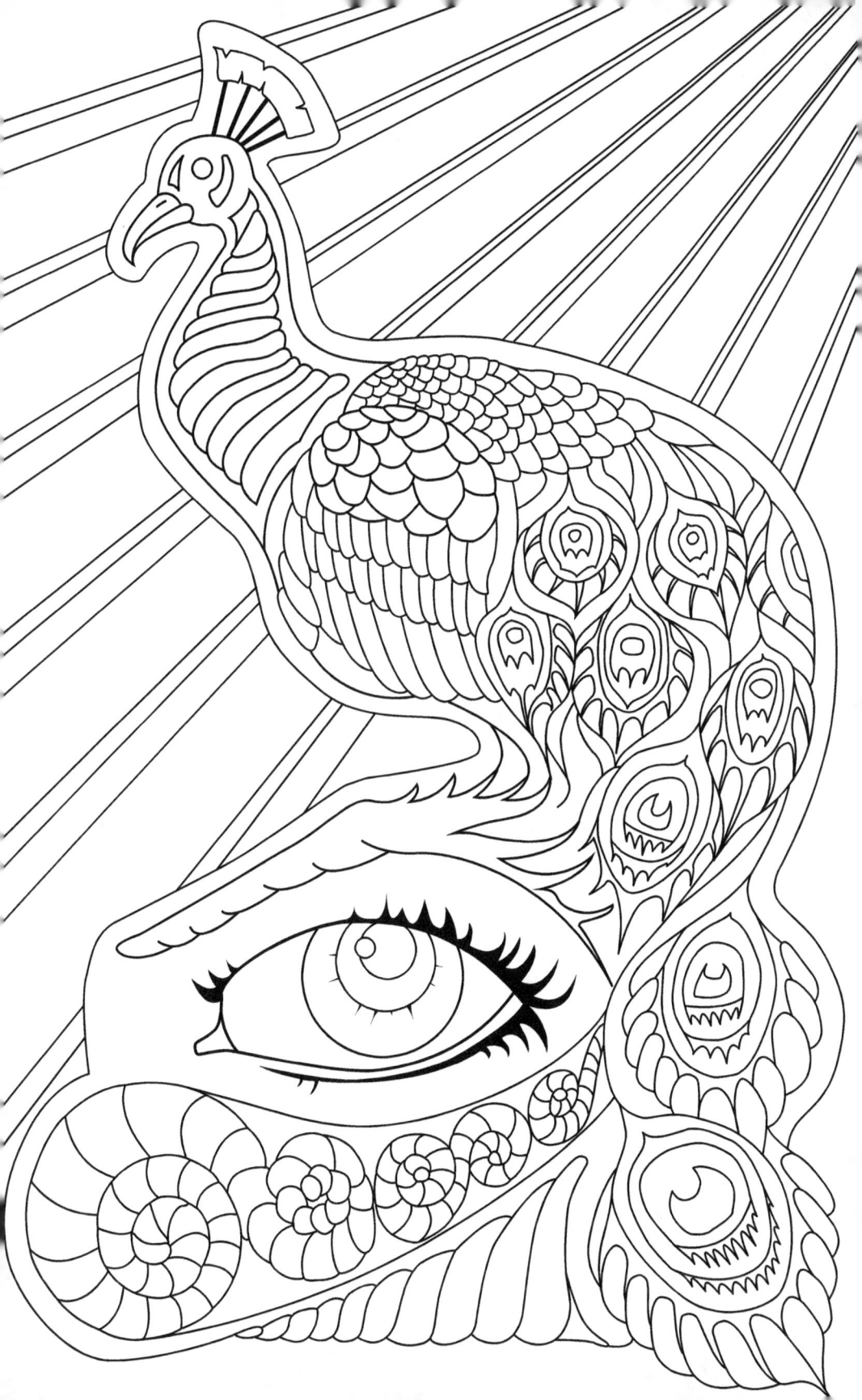

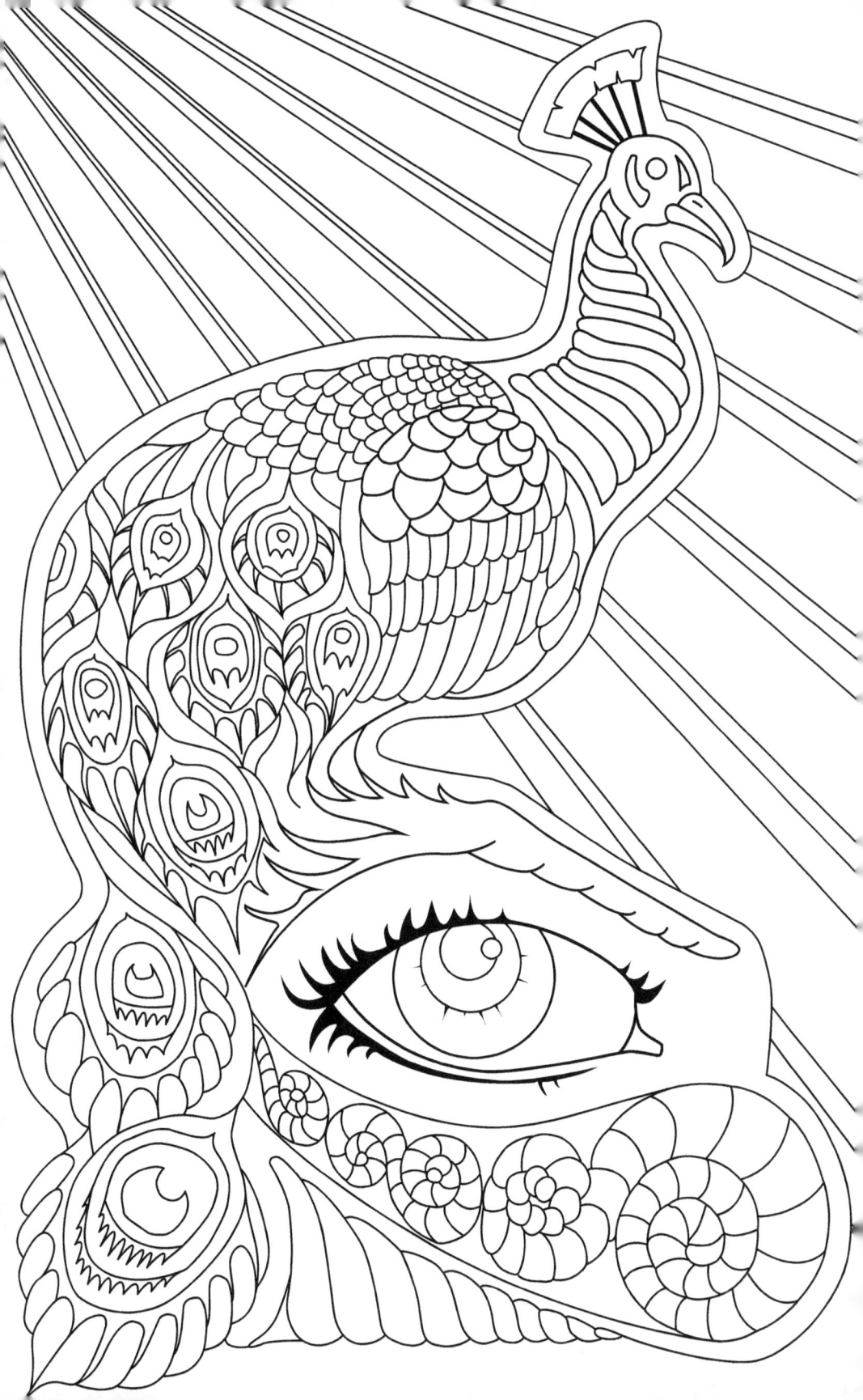

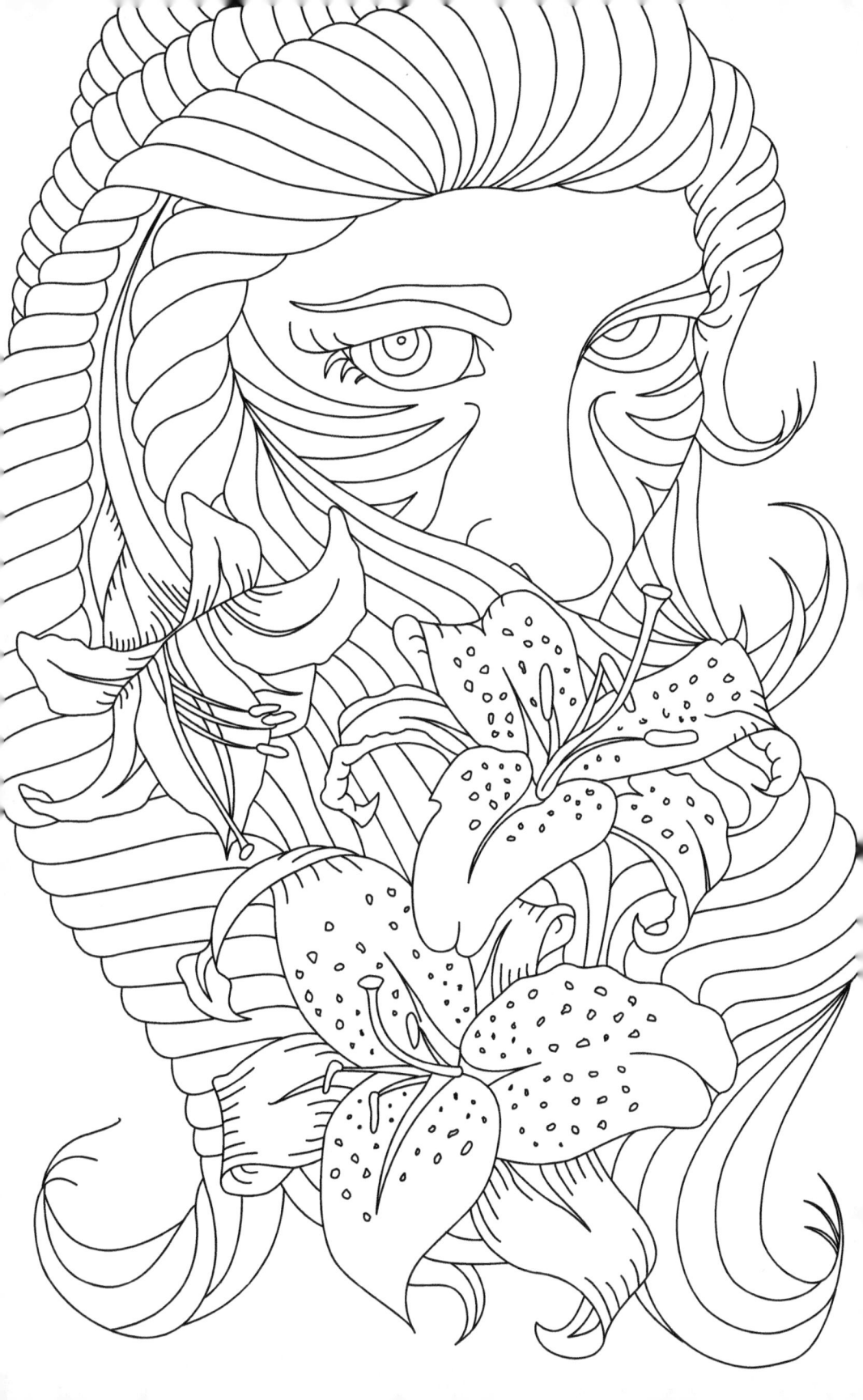

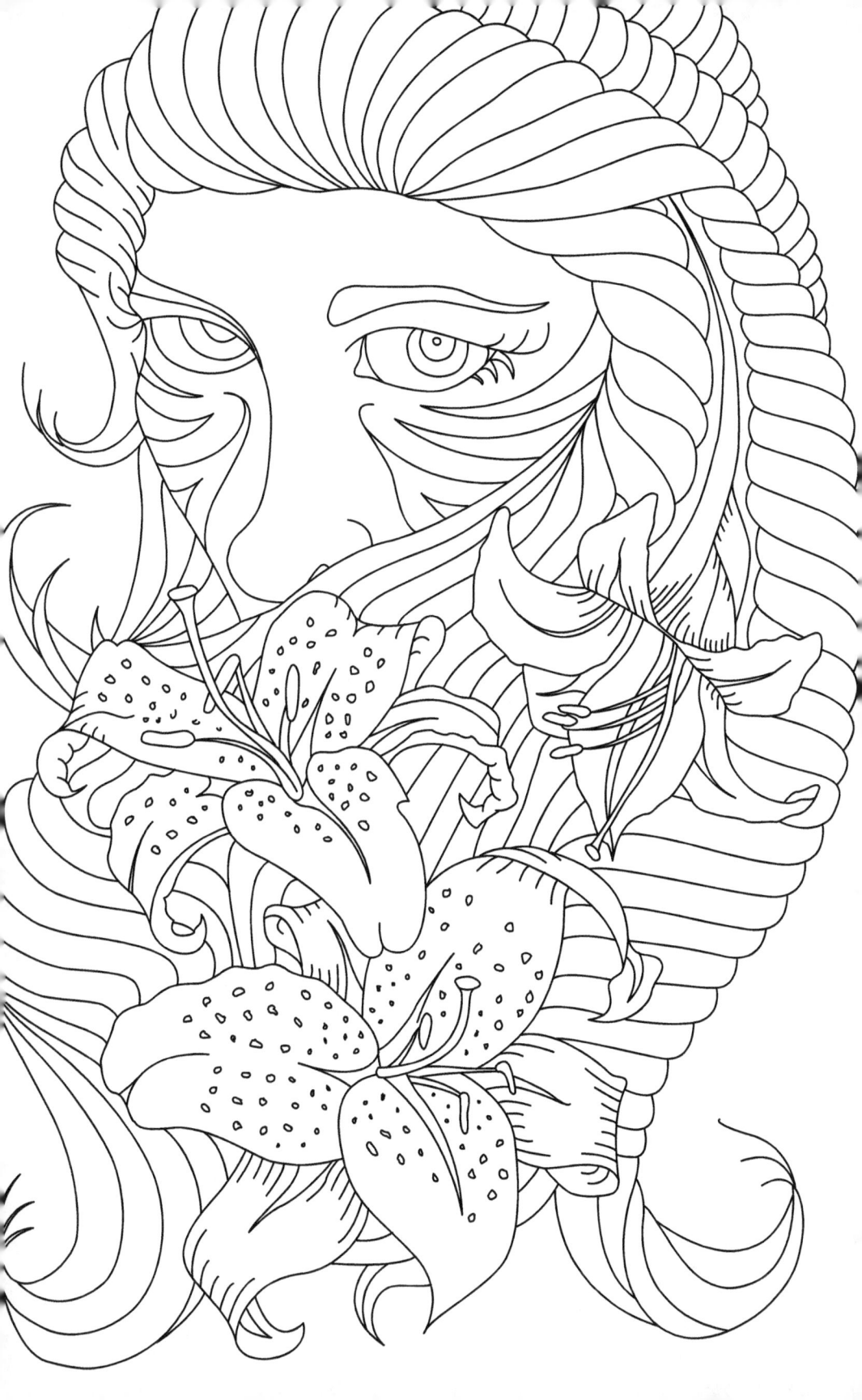

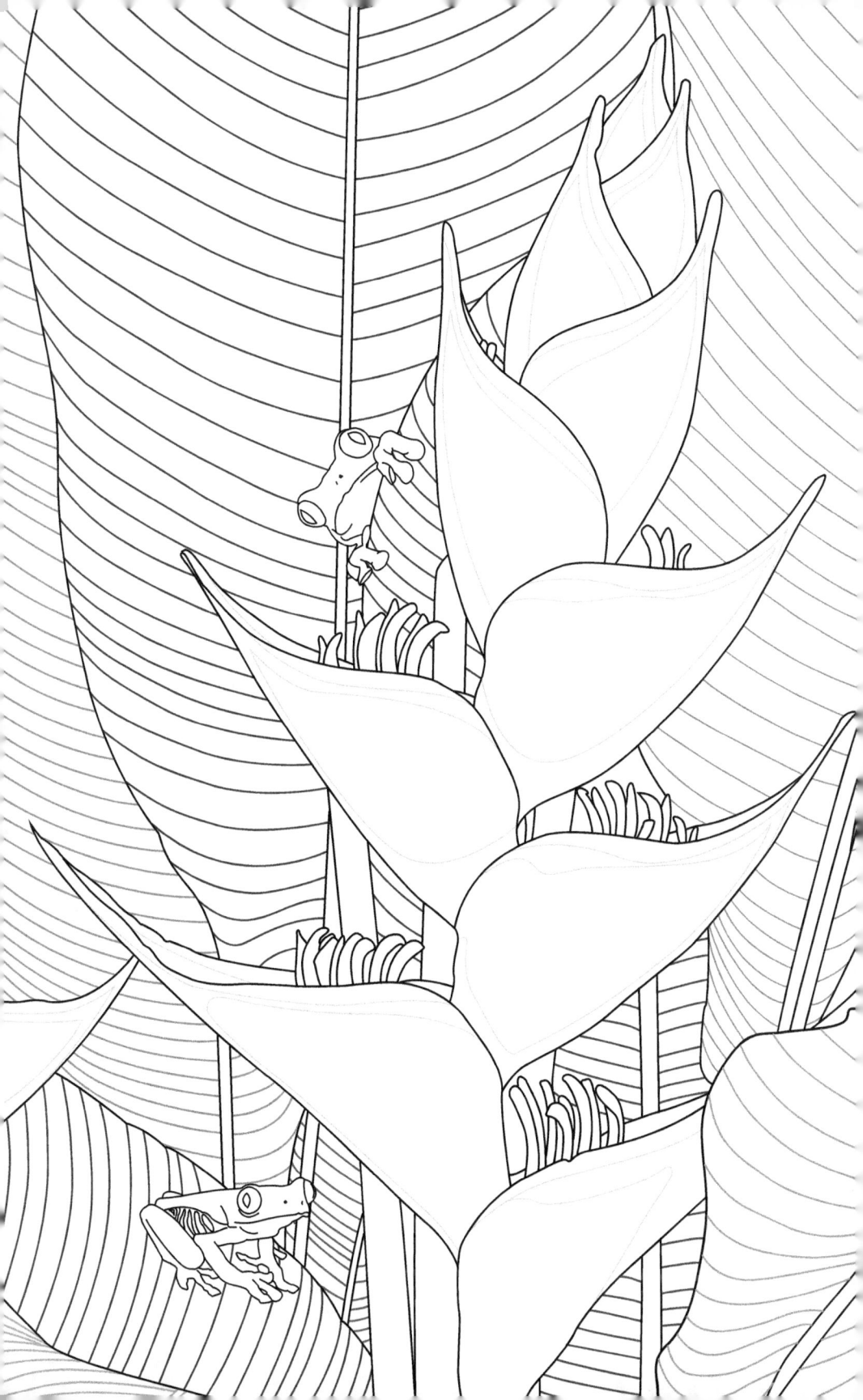

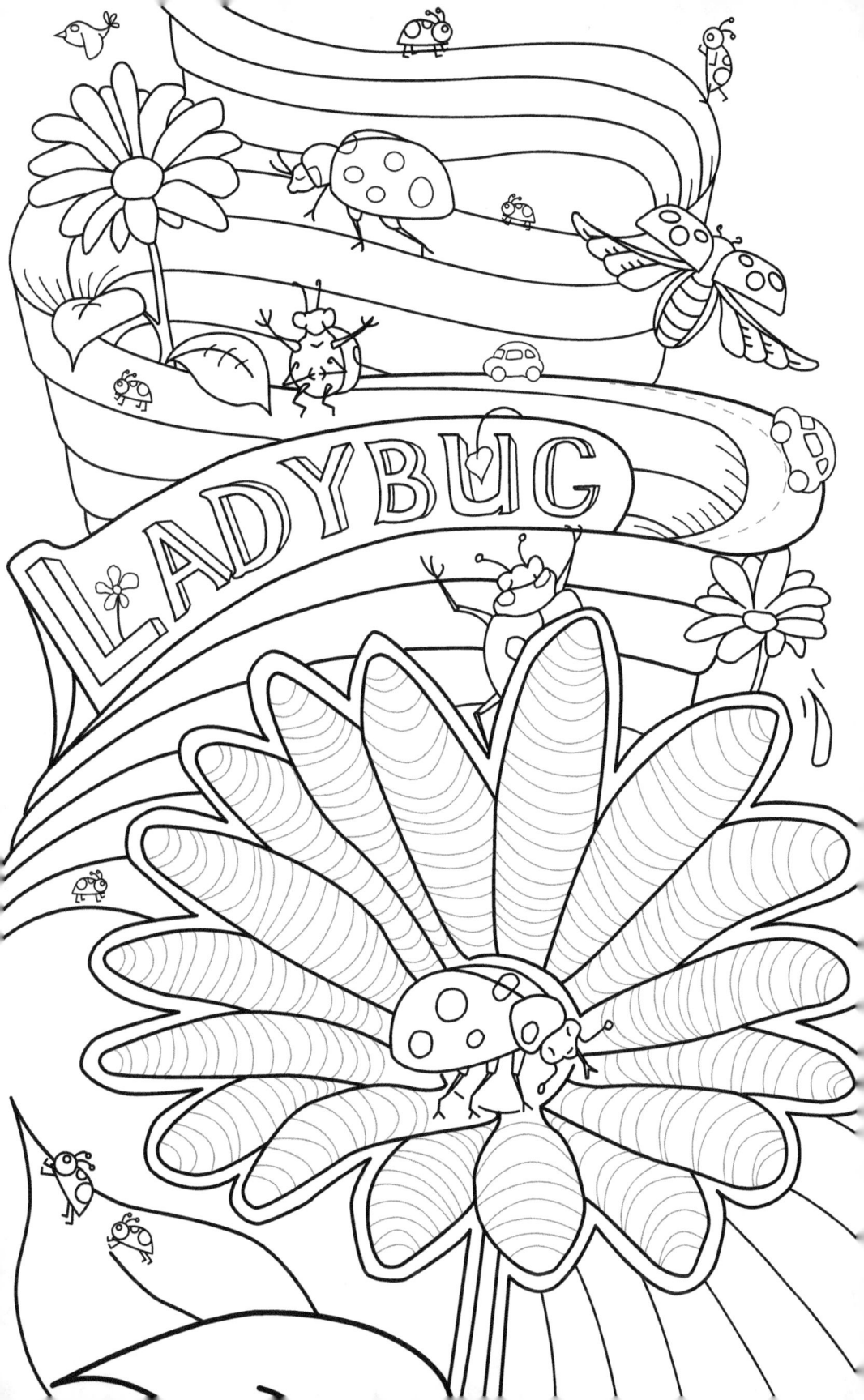

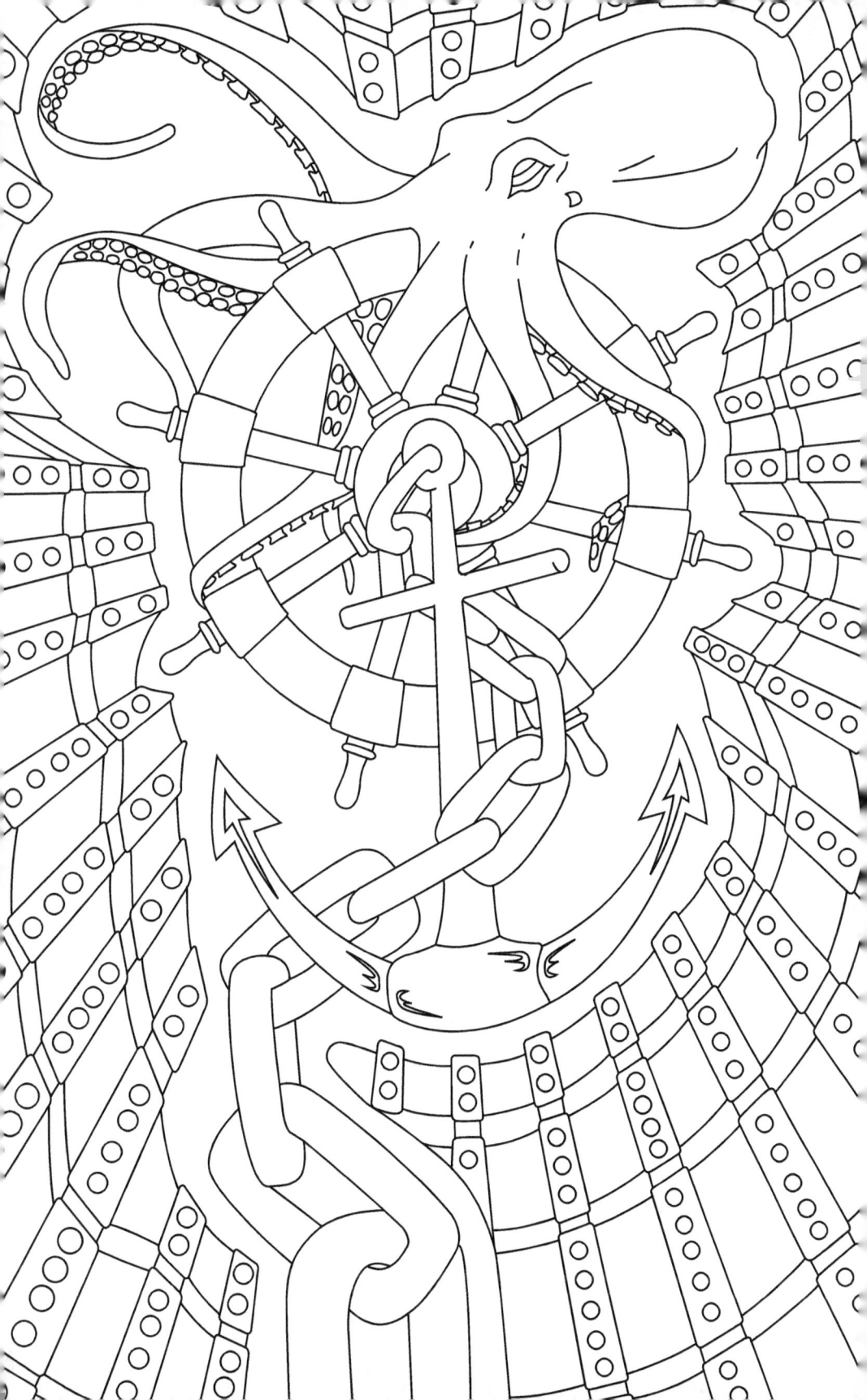

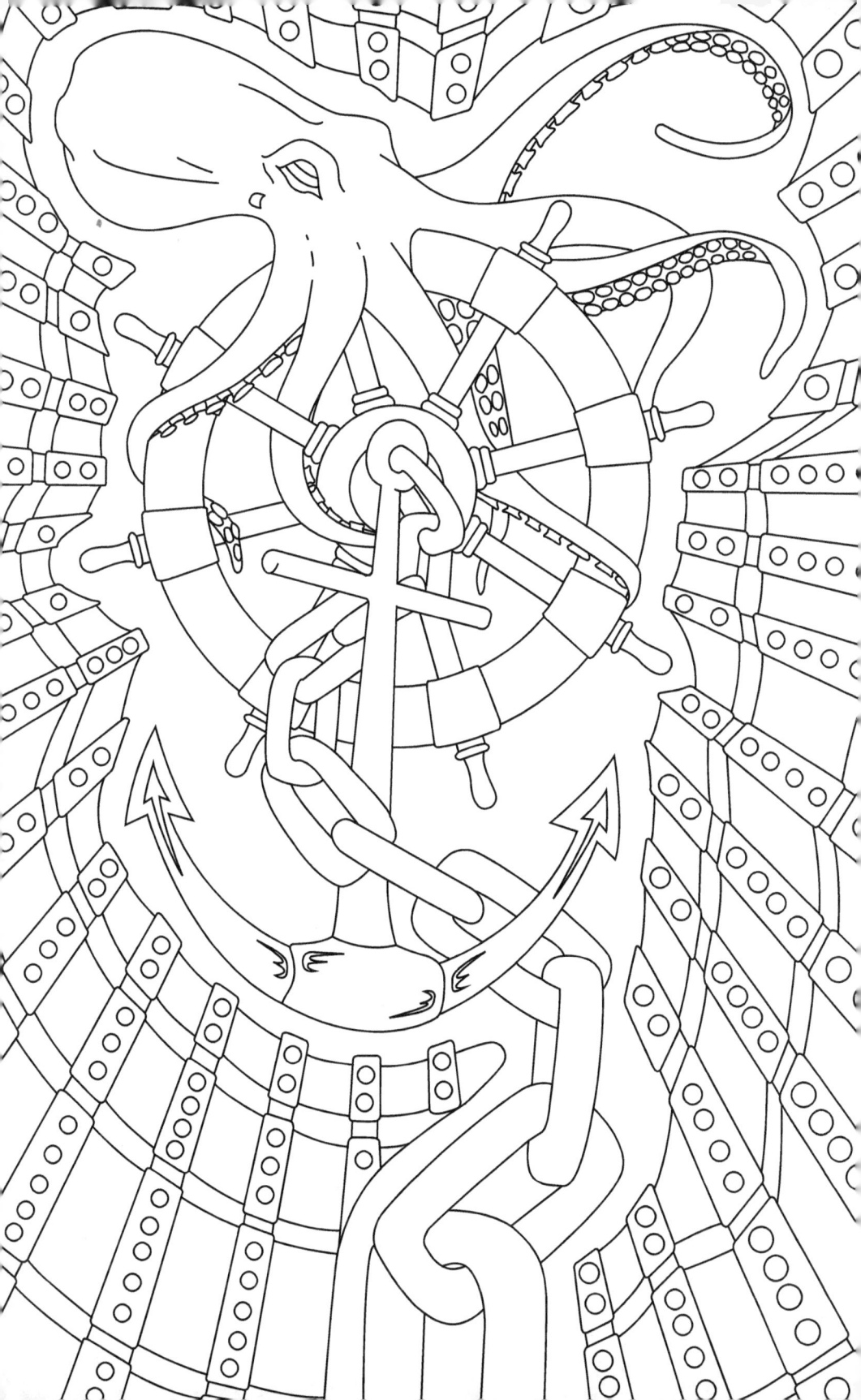

www.ingramcontent.com/pod-product-compliance
Lightning Source LLC
Chambersburg PA
CBHW060421190526
45169CB00002B/996